FIGHTING FISH / FIGHTING BIRDS

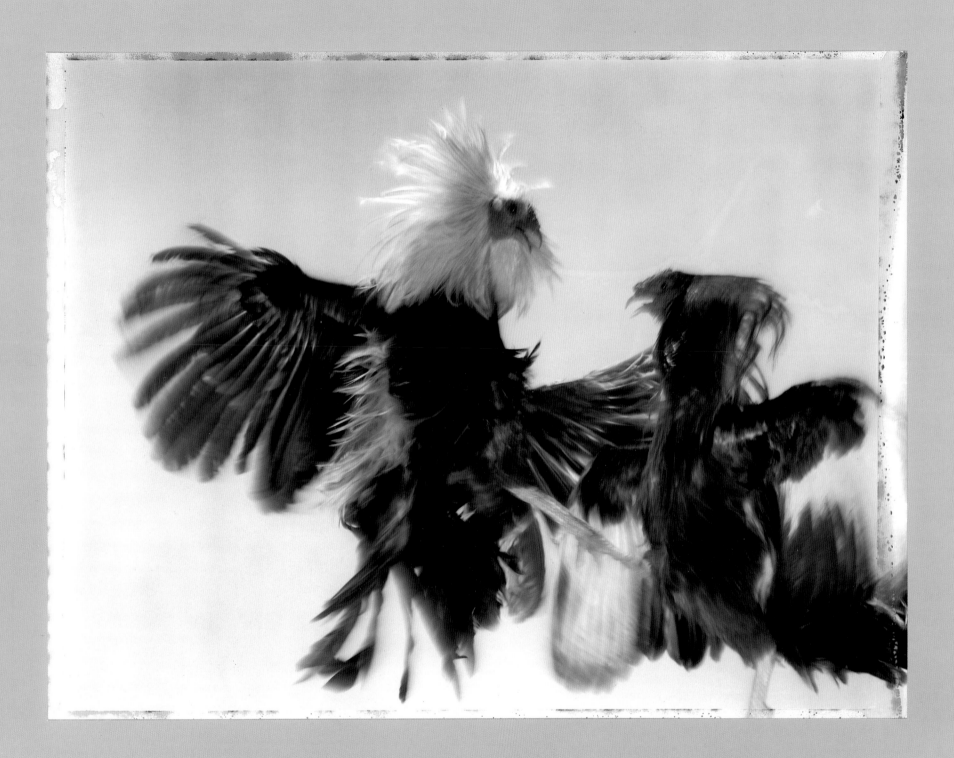

FIGHTING FISH / FIGHTING BIRDS

PHOTOGRAPHS BY HIRO

ESSAY BY SUSANNA MOORE

HARRY N. ABRAMS, INC., PUBLISHERS, NEW YORK

CONTENTS

HIRO KNOWS THAT THERE IS BEAUTY IN THE STRANGE CIRCUMSTANCE OF SURVIVAL. THESE NEARLY ABSTRACT IMAGES OF FIGHTING BIRDS AND FIGHTING FISH ARE THE PROOF OF IT. IN THE TEN YEARS THAT IT TOOK TO PHOTOGRAPH THESE BATTLES, THESE ENDURANCES, OF FIGHTING FISH AND FIGHTING COCKS, HIRO WAS DRAWN ON BY THE CHANCE OF DISCOVERING BEAUTY IN A SITUATION THAT DID NOT, IN ITSELF, REPRESENT AN AESTHETIC TRADITION.

THE PHOTOGRAPHS ARE NOT ARRANGED IN ORDER OF BATTLE. THE SEQUENCE IN WHICH ONE LOOKS AT THEM DOES NOT SIGNIFY BECAUSE IN BEAUTY (AS OPPOSED TO WAR)—THAT IS, IN THE SPECIFIC MOMENT OF EXISTENCE, TO USE HIRO'S WORDS—THERE IS NO ORDER.

THE IMAGES ARE AN EXAMPLE OF THE UNSEEN MADE SEEN. IN THE STUDIO, THE FISH AND THE BIRDS, SUBJECT TO THE DISPASSIONATE PUSH AND PULL OF INSTINCT, WERE DIFFICULT TO CONTROL. THE ANIMALS WERE NOT EVEN CAPABLE OF CONTROLLING THEMSELVES: THEY SIMPLY ADHERED TO THE MYSTERIOUS RULES OF THEIR GENETIC RITES. THE ANIMALS WERE UNPREDICTABLE, AND IMPERVIOUS TO A PHOTOGRAPHER'S ARRANGEMENT.

THE SUDDEN SPEED WITH WHICH THE ANIMALS JOIN OFTEN MAKES THEM INDISTINGUISHABLE ONE FROM THE OTHER; AN ENVELOPING BY WING AND TAIL. THE FEW STARTLING MOMENTS WHEN THE BULLET HEAD OF A FISH IS SUDDENLY DISCERNIBLE, OR THE HAUGHTY BEADY-EYED PROFILE OF THE COCK LUNGES OUT FROM ITS FEATHERED CLOAK, ARE DISTURBING BECAUSE THE HEADS ARE SO LIKE THOSE OF HUMANS, SOMETIMES EVEN HUMANS WHOM WE RECOGNIZE.

AS A CHILD, I USED TO WATCH THE FILIPINO MEN IN THE WORKERS' CAMP OF A SUGAR PLANTATION AS THEY SQUATTED IN THE DIRT AFTER A LONG DAY IN THE FIELDS. EACH MAN WOULD HOLD BETWEEN HIS

OPEN THIGHS A FIGHTING COCK AND HE WOULD DANDLE THE MESMERIZED BIRD RHYTHMICALLY UP AND DOWN ON THE ROUGH GROUND TO STRENGTHEN ITS LEGS. I, TOO, WAS HYPNOTIZED. AND LATER, WHEN I WAS OLDER AND ALLOWED TO SQUEEZE INTO THE SWAYING RING OF MEN AT A COCKFIGHT, I WOULD CROUCH LOW ON MY HEELS, JOSTLED AND SOMETIMES EVEN KNOCKED OVER, TO WATCH THEM, THE MEN NOT THE BIRDS, IN TERRIFIED AND EXCITED ASTONISHMENT.

A COCKFIGHT IS NOT ONLY AN INSTINCTIVE DARWIN-IAN CONTEST OF SEX AND SURVIVAL FOR THE BIRD, BUT FOR THE TRAINERS AND HANDLERS AS WELL, AND FOR THE MEN WHO WATCH THE FIGHTS, GAMBLING LOUDLY AND ROUGHLY, ALMOST AS IF THEY WERE IN MORTAL COMBAT THEMSELVES. IN ITS MOST PRIMI-TIVE, AND THUS IN SOME WAYS ITS MOST SOPHISTI-CATED, STATE, THE FIGHTING OF COCKS AND FISH FOR SPORT COMBINES IN ONE SATISFYING AND SYM-BOLIC CONTEST THE RITES OF MALE NARCISSISM,

ANIMISM, GROUP HYSTERIA, AND SACRIFICE. THESE FIGHTS TO THE DEATH ARE ABOUT CREATION IN THE MOST LITERAL AS WELL AS THE MOST POETIC SENSE.

THE FIGHTING FISH AND THE FIGHTING COCKS PER-FORM A VERY OLD DANCE. AND THE DANCE THAT THEY DO IS SEXUAL. BOTH THE COCKS AND THE FISH ARE PARTICULARLY RESPLENDENT BEFORE THE FIGHT. THEIR COLOR IS VIVID: COXCOMBS SUFFUSED AND SWOLLEN WITH BLOOD; GILLS EXPANDED, EYES DILATED AND BULBOUS. THE BIRDS LOOK LIKE WAR-RIORS IN BRISTLE-RIDGED HELMETS. THEY LOOK LIKE SHAMANS PLACATING THE SKY GOD. THE FISH LOOK LIKE KITES ON BOYS' DAY; FLOATING STRIPS OF PLEATED OBI SILK; EMBLAZONED MEDIEVAL BANNERS; FLESH-EATING FLOWERS. THE FIGHTING COCKS ARE HOT; THE FISH COOL.

BEFORE THE MATCH, THE INTEMPERATE COCK IS EAGER AND EXCITED; THE SIAMESE FIGHTING FISH IS CAU-TIOUS, PERHAPS BECAUSE IT HAS NOT BEEN TRAINED

TO FIGHT. THE COCK ATTACKS WITH NATURAL SPURS THAT HAVE BEEN SHARPENED, OR WITH RAZORS LASHED TO ITS FEET; THE DECOROUS FISH, ONLY ONE AND A HALF INCHES LONG, TAKES DEADLY NIPS FROM THE UNDULATING TAIL AND FINS OF ITS RIVAL. WHEN PULLED APART, THE COCKS ARE COVERED WITH MUCUS AND BLOOD; THE FISH, AT THE END, WEAKLY SPLAY SHREDDED FINS THAT ARE SEEMINGLY DAMAGED NO MORE THAN THE RAIN-TATTERED LEAVES OF BANANA TREES. THE COCKS FLY AT EACH OTHER AT THE SAME, ALWAYS SHOCKING, INSTANT; WITH THE RUFFLED, MUFFLED SOUND OF THE RISING AND BEATING OF WINGS AS THEY PIERCE AND STRIKE EACH OTHER. THIN BONE AND SOFT FEATHER SHOULD NOT SOUND SO FIERCE. THE SILENT FISH BUMP EACH OTHER IN SLOW, PROVOCATIVE EXPLORATION BEFORE THEY ATTACK AND THE ATTACK RESEMBLES NOTHING SO MUCH AS AN ACT OF LOVE. VICIOUS AND UNRELENTING, THE COCKS RISE UP AGAIN AND AGAIN WITH THE BUOYANCY OF THEIR FEATHERS. THE COCKS ARE AN ASCENDING VERTICAL; THE FISH ARE WEAVING, WINDING HORIZONTALS. IF THE COCKS ARE OF THE AIR, ALL AERODYNAMICS AND LIFT, THE SINUOUS FISH ARE INDEPENDENT OF THE AIR.

THESE PHOTOGRAPHS OF FIGHTING FISH AND FIGHTING COCKS—BOTH WATER-SATURATED AND DRY, LOOSE AND TIGHT, FULL OF FOLKLORE, LEGEND, AND EVEN HISTORY—HAVE AN EMOTION THAT COMES BOTH FROM THEIR ANTHROPOMORPHIZATION AND FROM THEIR INTIMATE VITALITY. ALTHOUGH A TOO FREQUENT RECOURSE TO THE REFERENTIAL IS TO BE RESISTED—THAT IS, THE INCLINATION TO FIND IN EVERYTHING VESTIGES AND REMINDERS OF SOMETHING ELSE—IT IS IMPOSSIBLE WHEN LOOKING AT THESE PHOTOGRAPHS NOT TO THINK OF THE EARLY CHINESE LITERATI PAINTINGS OR THE EIGHTEENTH-CENTURY JAPANESE PAINTINGS KNOWN AS THE KANO SCHOOL, AND ESPECIALLY THOSE PAINTINGS OF INK ON PAPER BY THE BUDDHIST, JAKUCHŪ, WHO WAS FAMOUS FOR HIS LOVE OF CHICKENS. THERE IS SOMETHING PLEASING AND EVEN REASSURING IN THE

DISCOVERY, OFTEN NOT COMPLETELY CONSCIOUS, THAT WHAT ONE IS SEEING REPRESENTS NOT SO MUCH REFERENCE AS CONTINUITY.

FINALLY, AND DESPITE THE MYTHOLOGIZING, THE PHOTOGRAPHS ARE PROVOCATIVE. THE EMOTION-LESS, MONOCHROMATIC COCKS AND THE SENSUAL FISH ARE EMBLEMATIC AND EVEN ILLUMINATING. NATURE, IN THE END, WHETHER IT MANIFESTS ITSELF IN THE SEDUCTIVE DISPLAY OF BEAUTY THAT IN THE FISH IS BOTH SOLEMN AND GAUDY, OR IN THE COLD WORKADAY BELLIGERENCE OF THE ROOSTER, WILL ALWAYS HAVE ITS WAY. NATURE IS UNSENTIMEN-TAL; IT IS ONE OF ITS BEST CHARACTERISTICS. SO, TOO, ARE THESE PHOTOGRAPHS UNSENTIMENTAL. ONE DOES NOT FEEL PITY OR REVULSION LOOKING AT THEM, BUT A KIND OF HUMBLE RECOGNITION—IT IS NOTHING SO EARNEST AS TRANSCENDENTALISM OR SO FASHIONABLE AS THE NEW PANTHEISM: WE ARE NOT THE FISH. BUT WE ARE, AS ARE THE FIGHTING FISH AND THE FIGHTING COCK, GOVERNED BY OUR OWN DANCE OF SURVIVAL—A DANCE WE GLADLY JOIN, WITH ITS VERY OLD FEINTS AND PASSES AND TURNS— THAT IS BOTH OUR BEGINNING AND OUR END.

—SUSANNA MOORE

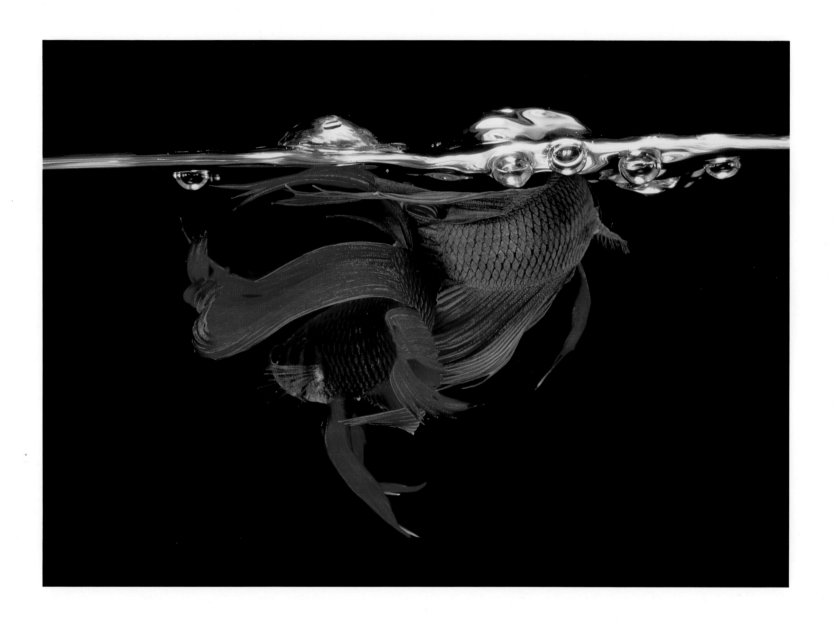

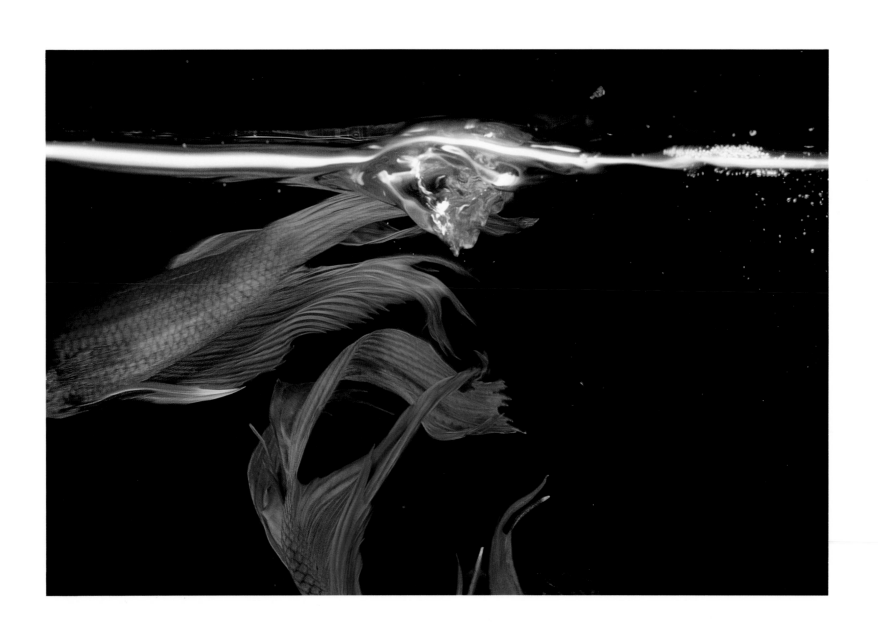

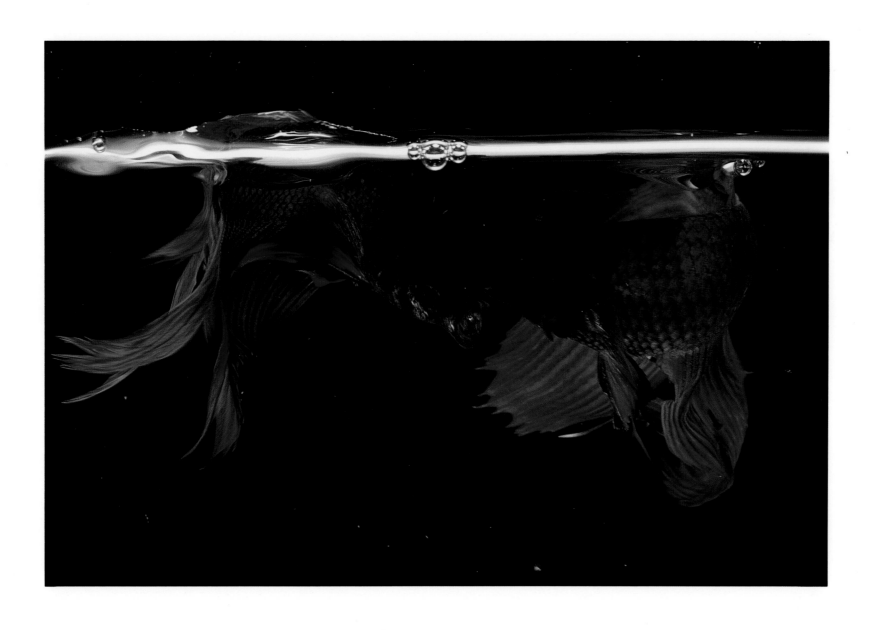

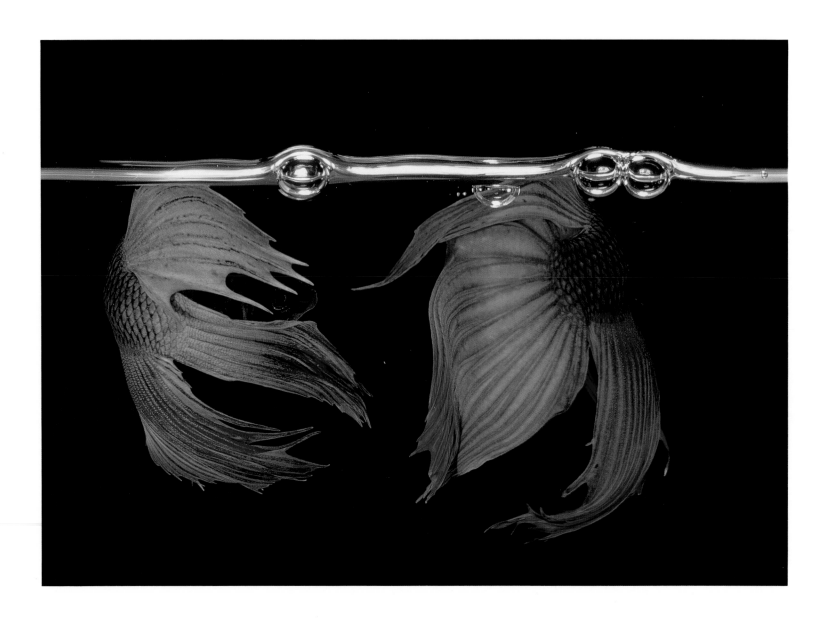

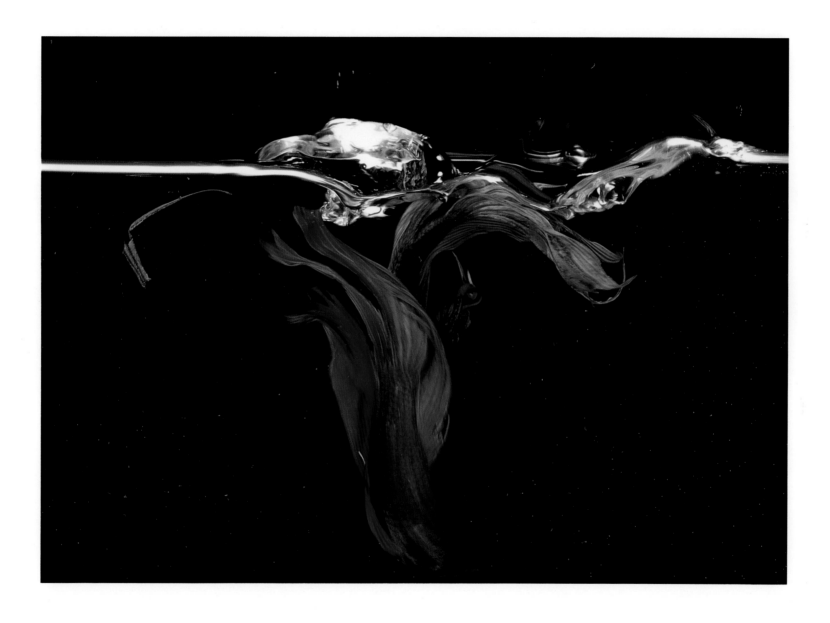

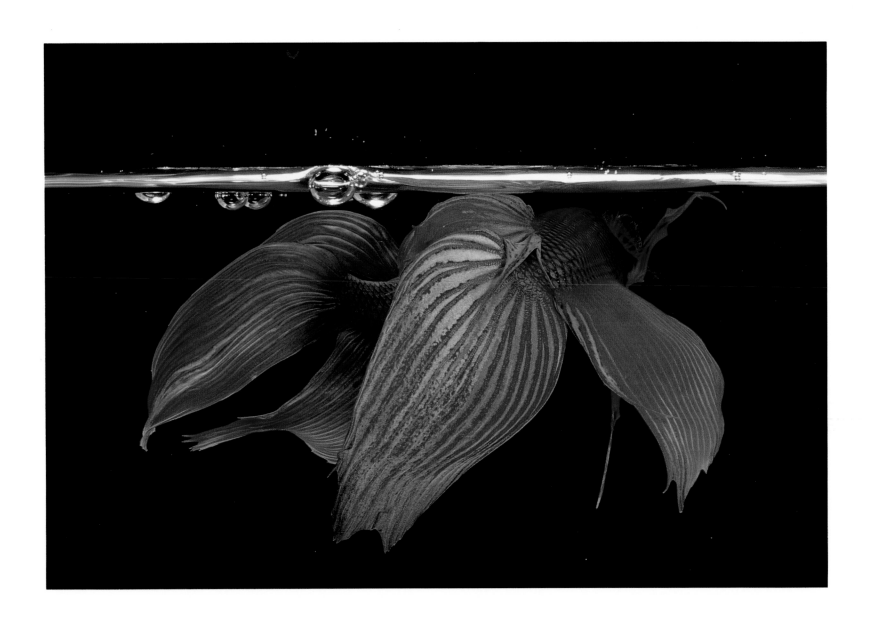

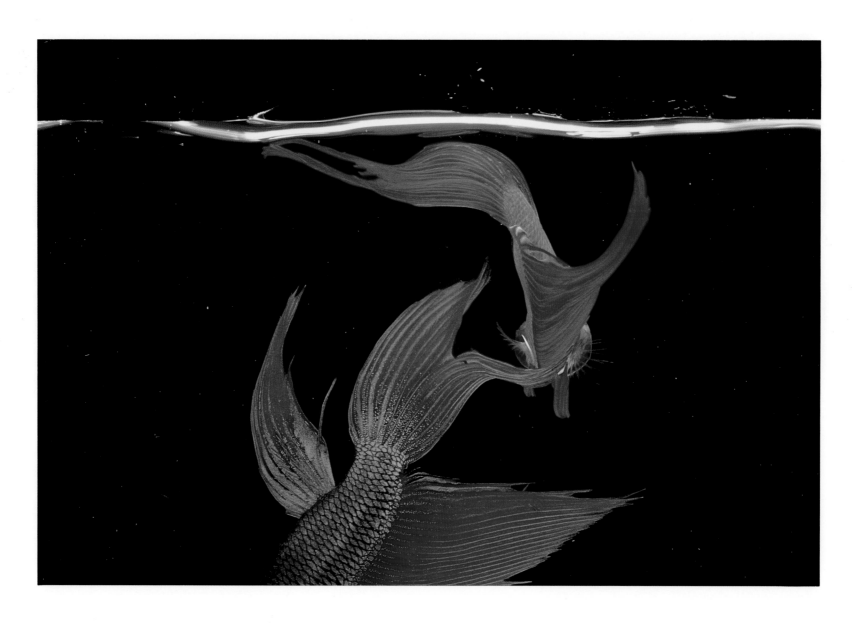

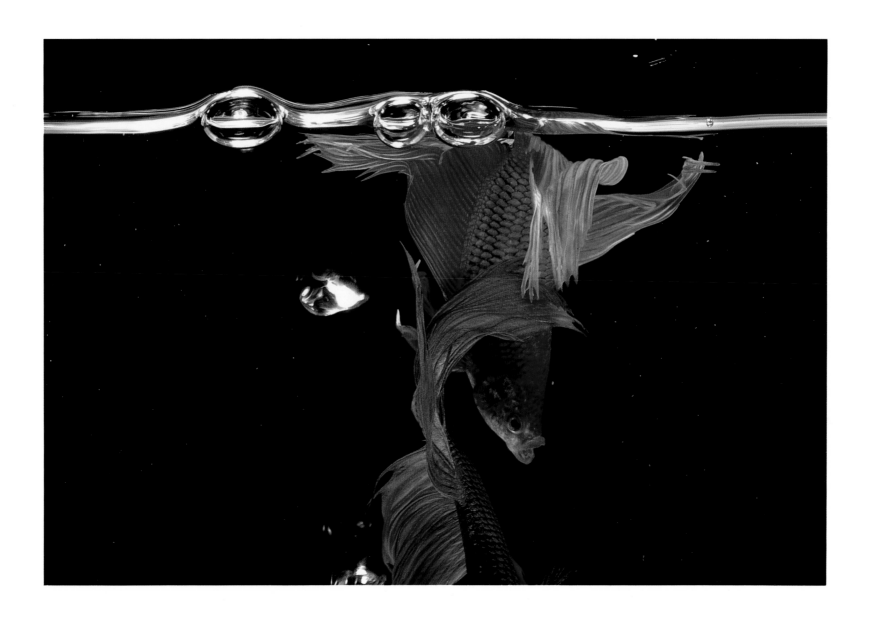

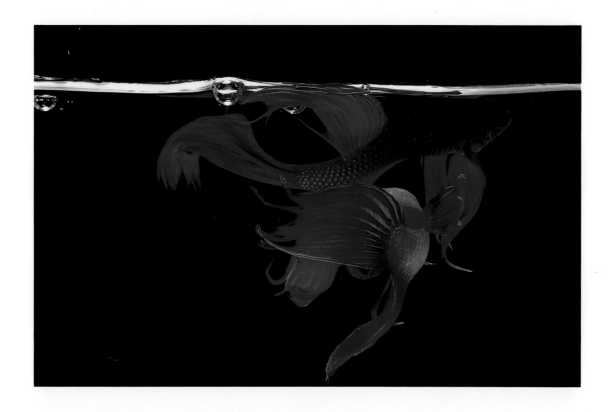

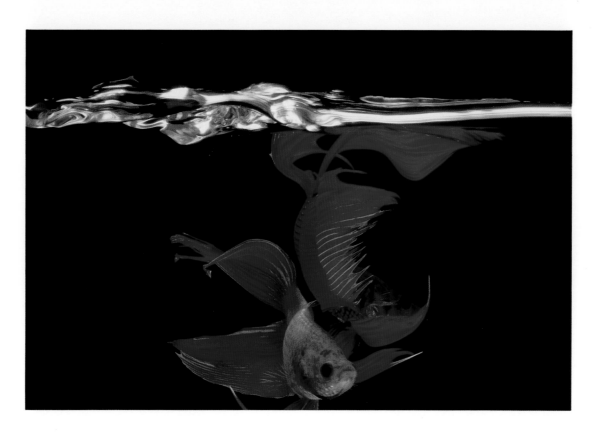

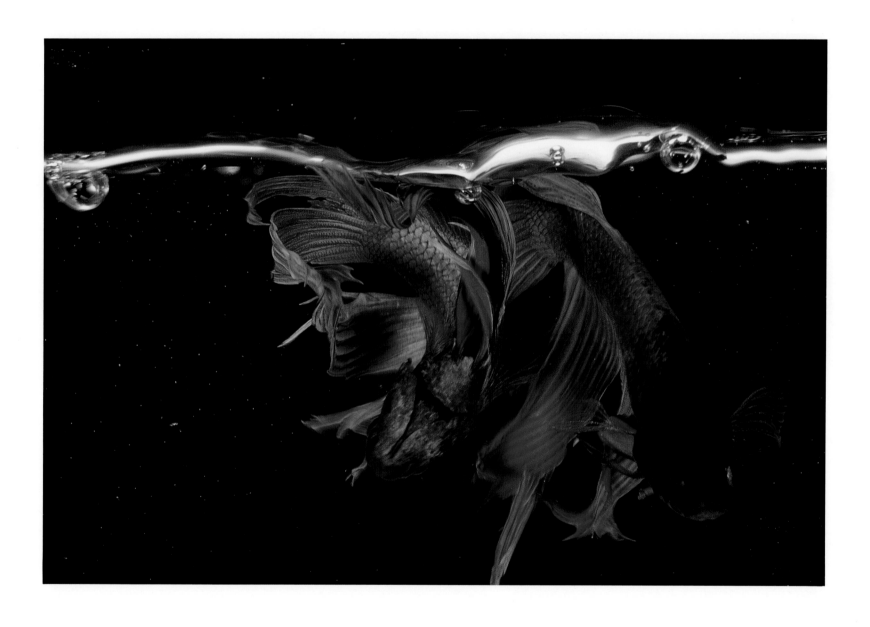

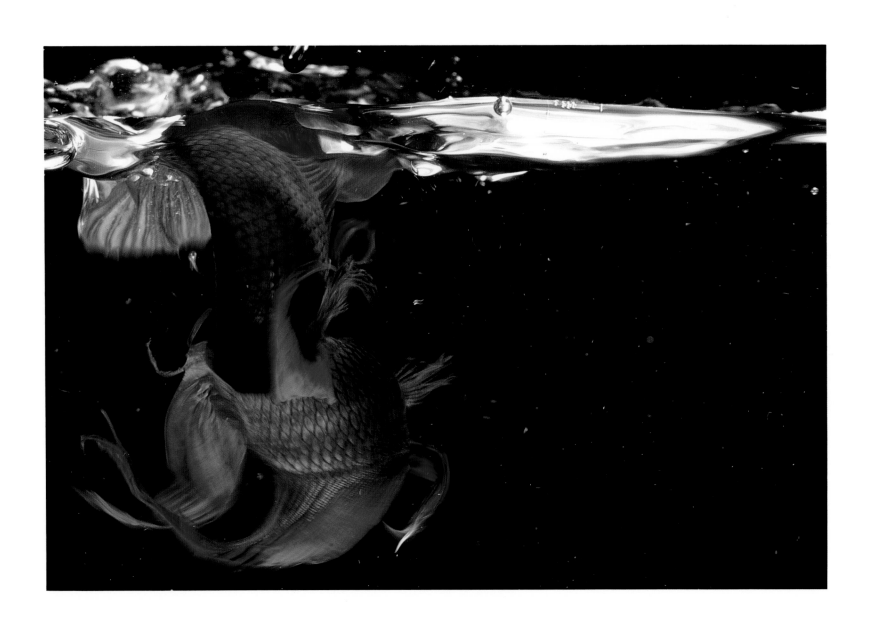

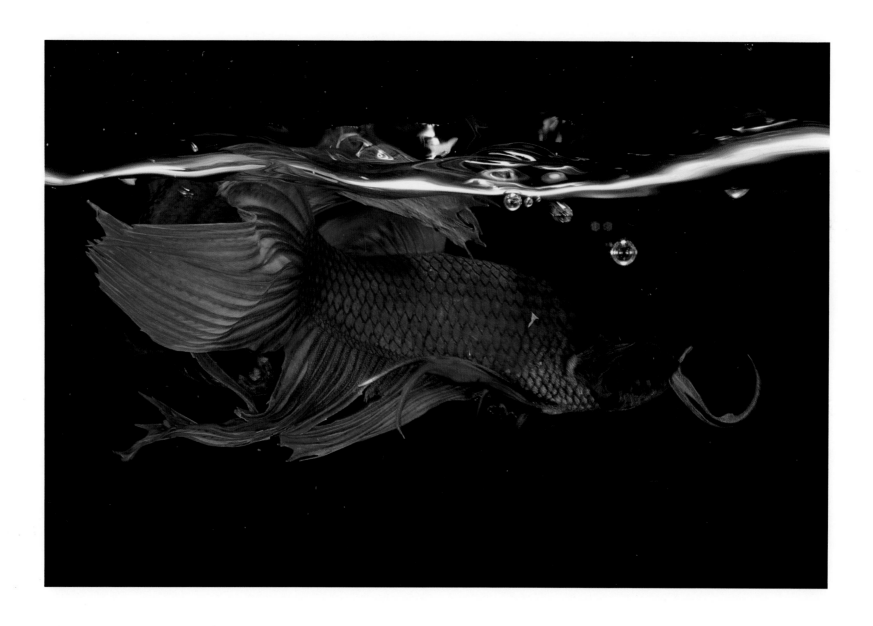

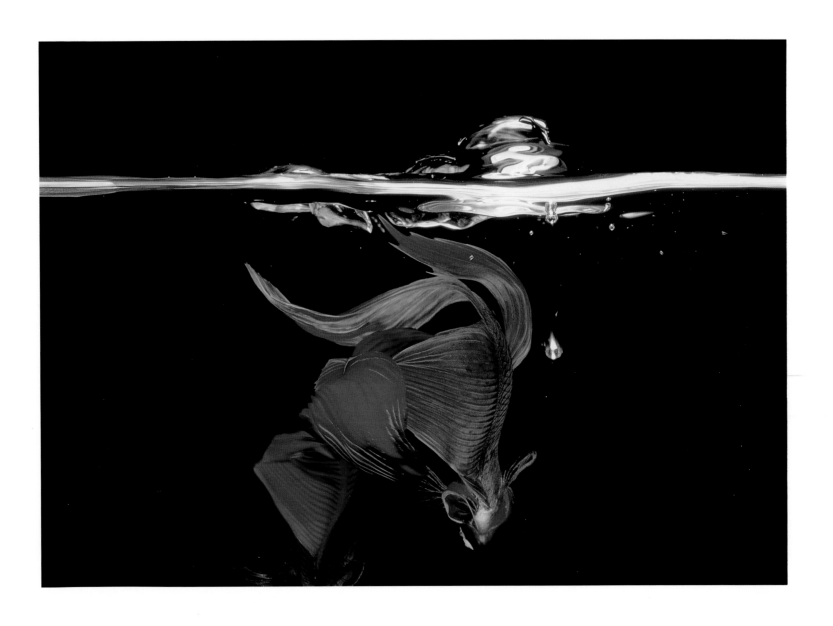

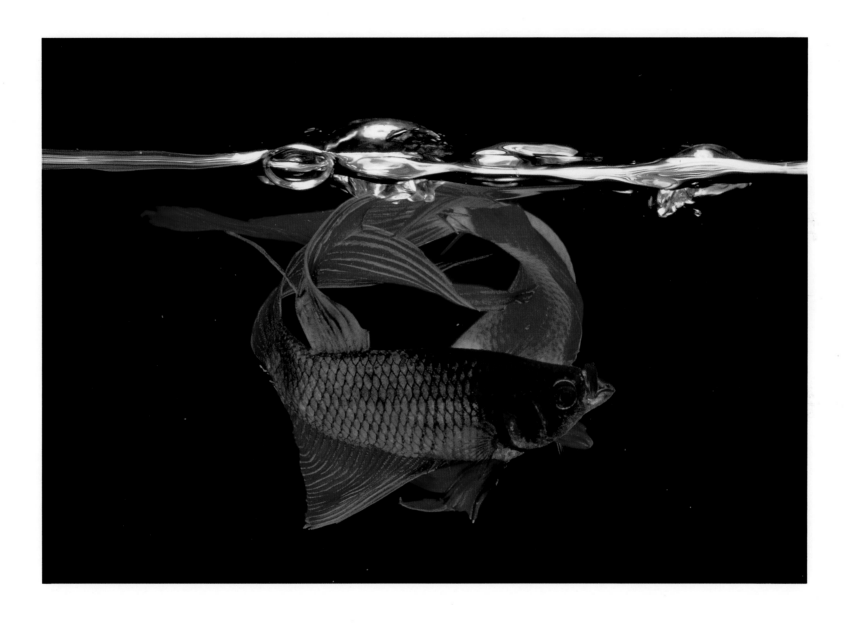

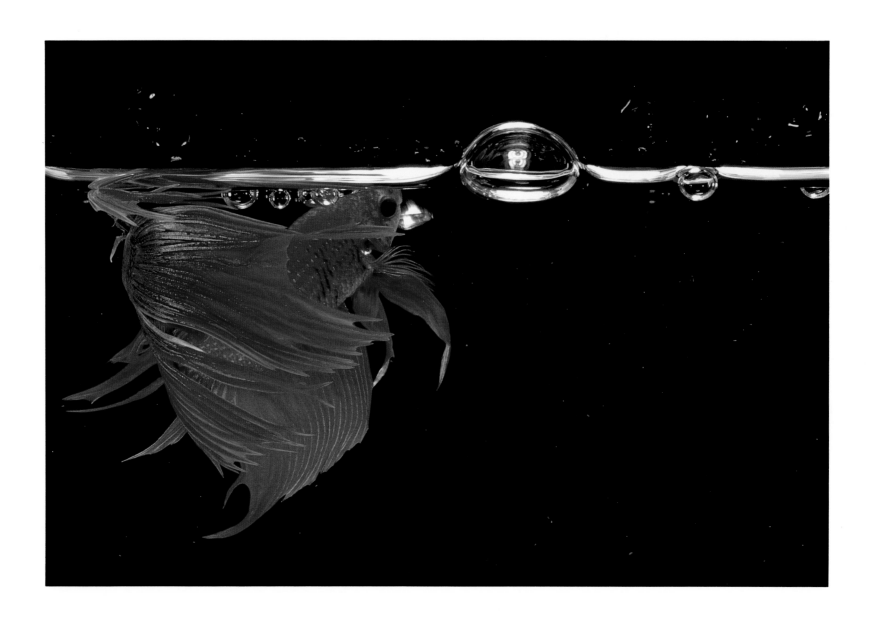

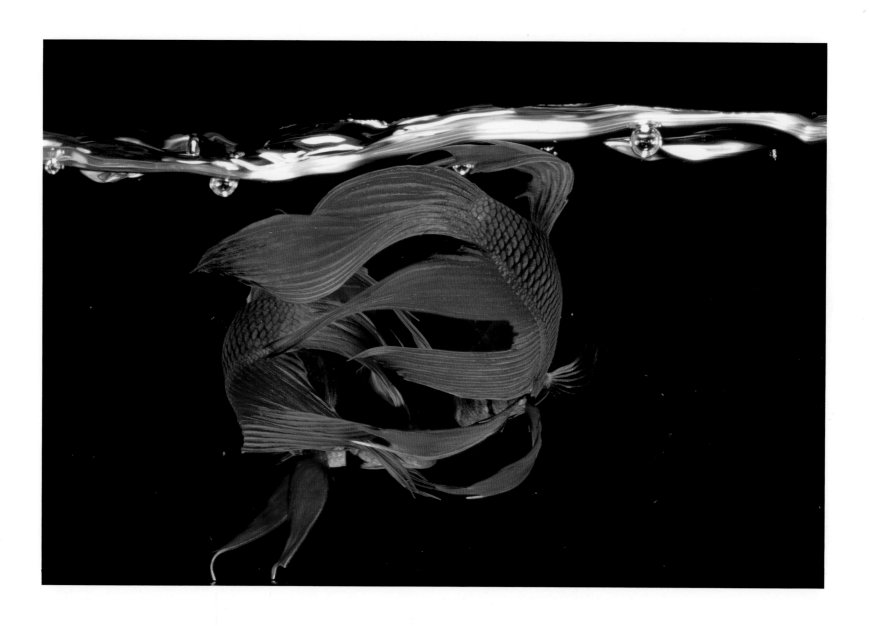

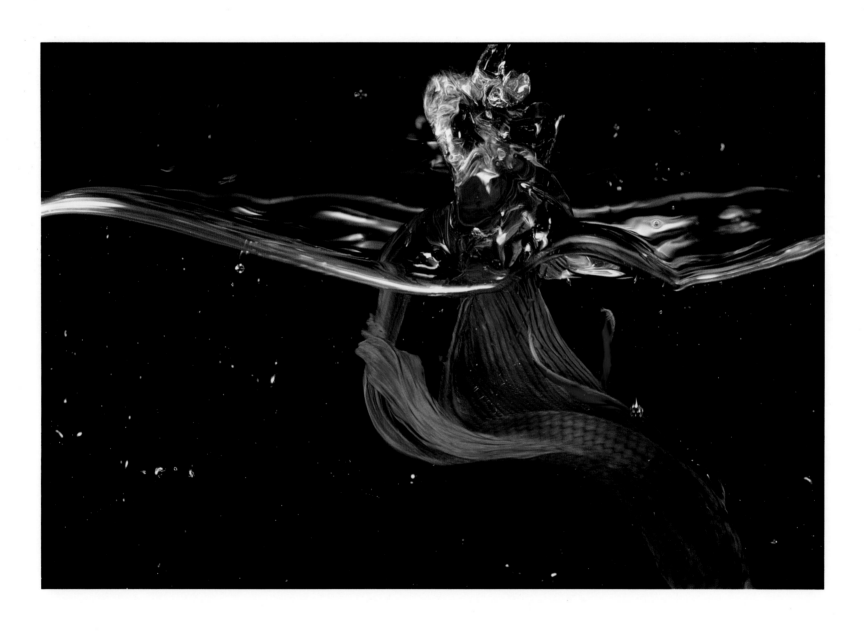

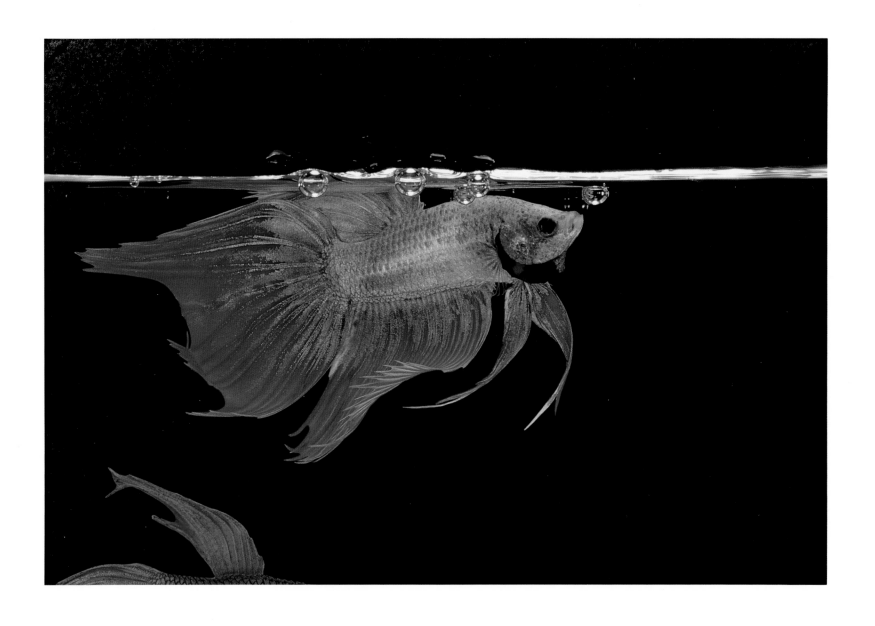

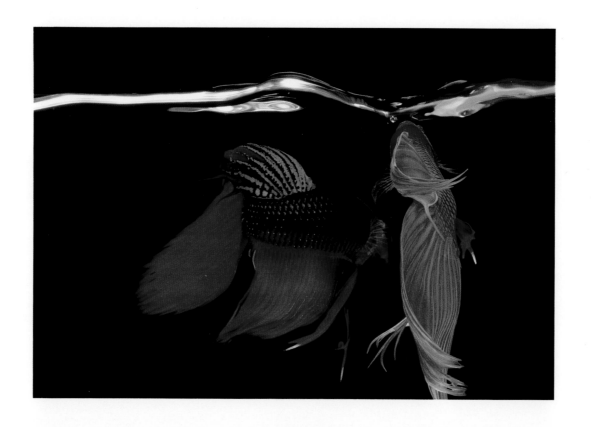

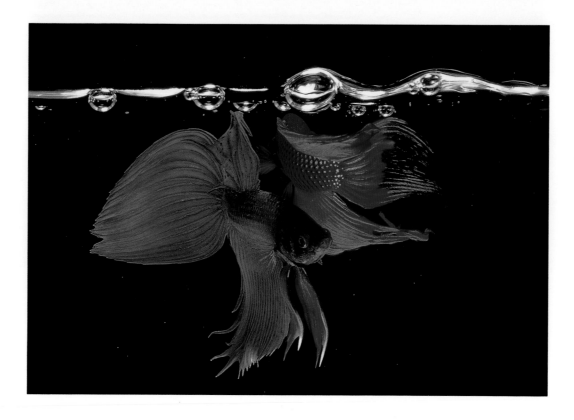

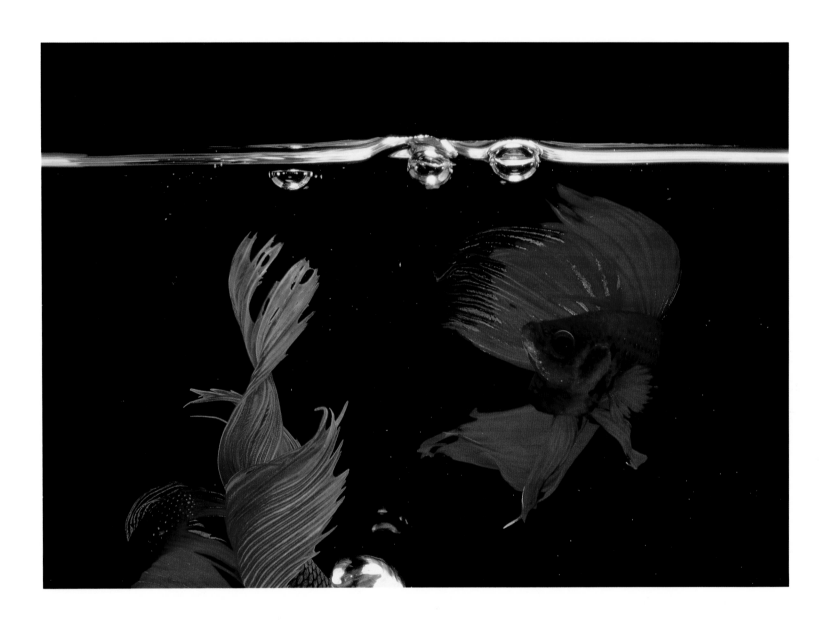

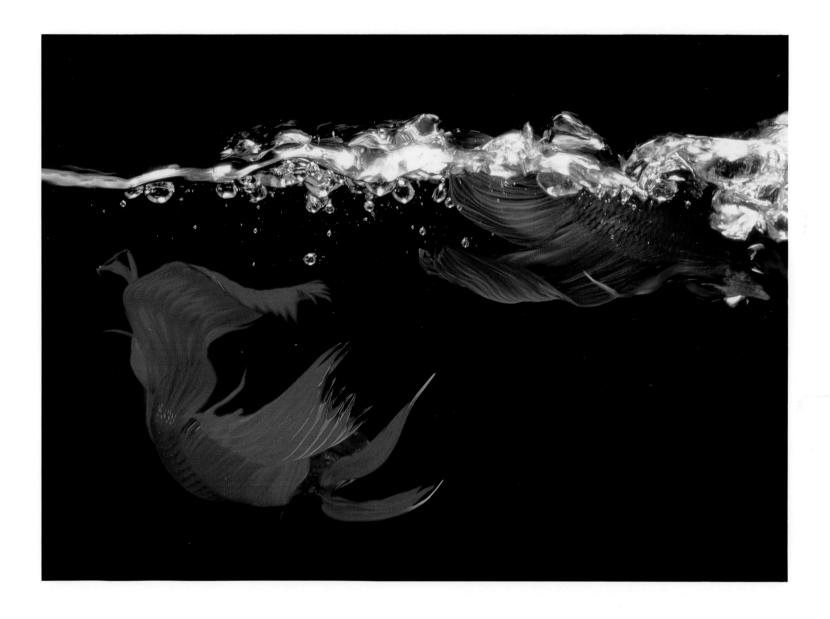

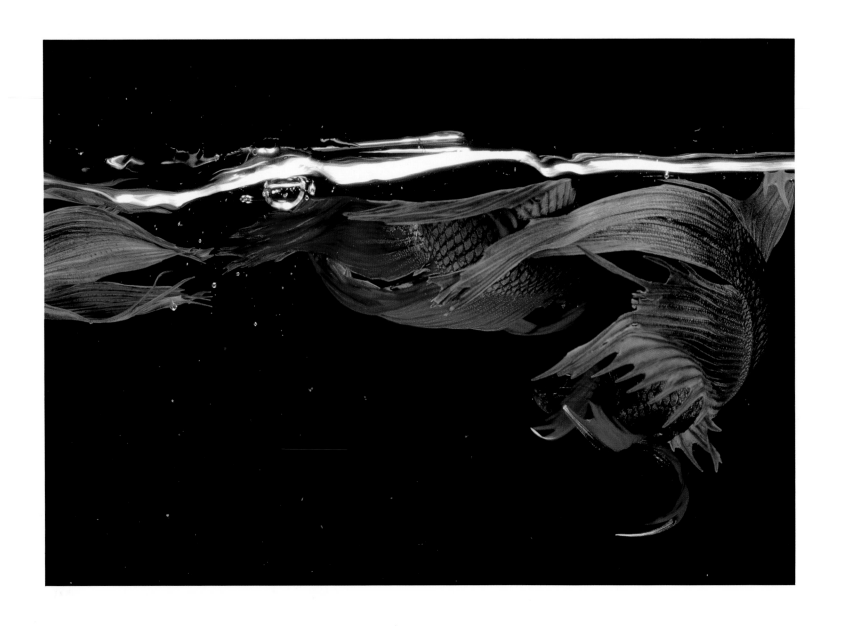

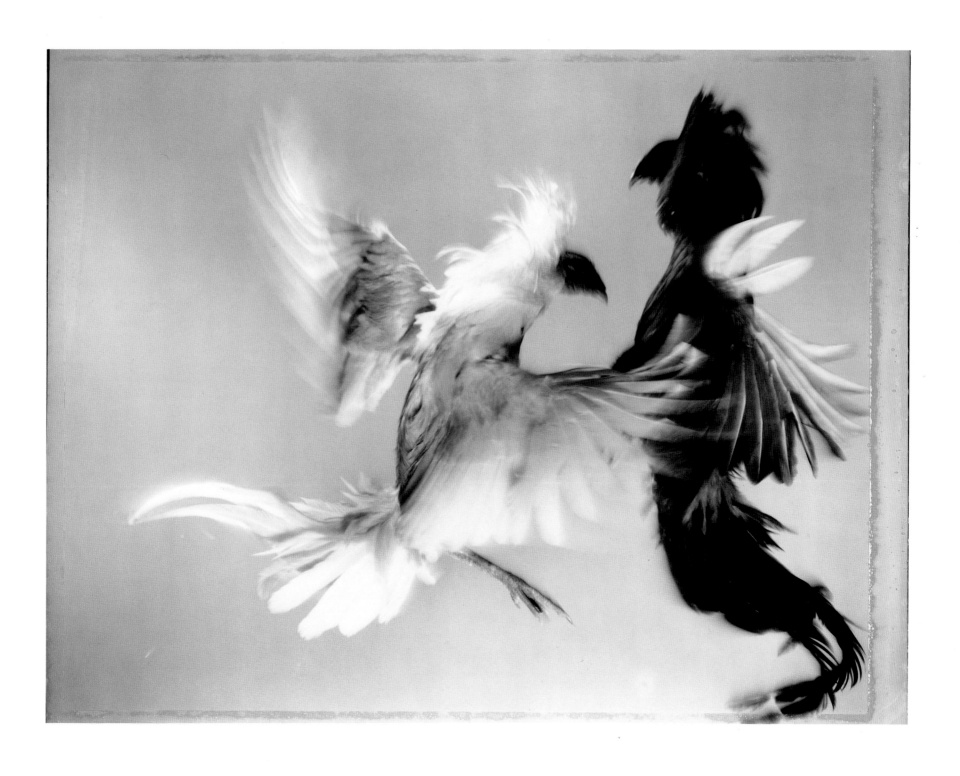

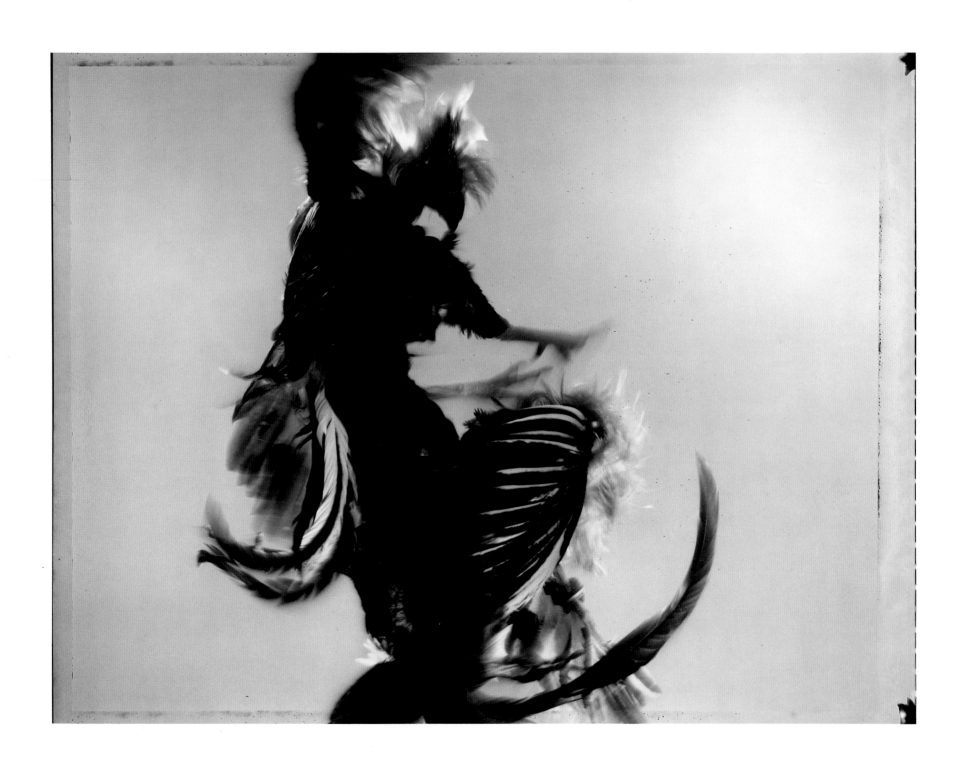

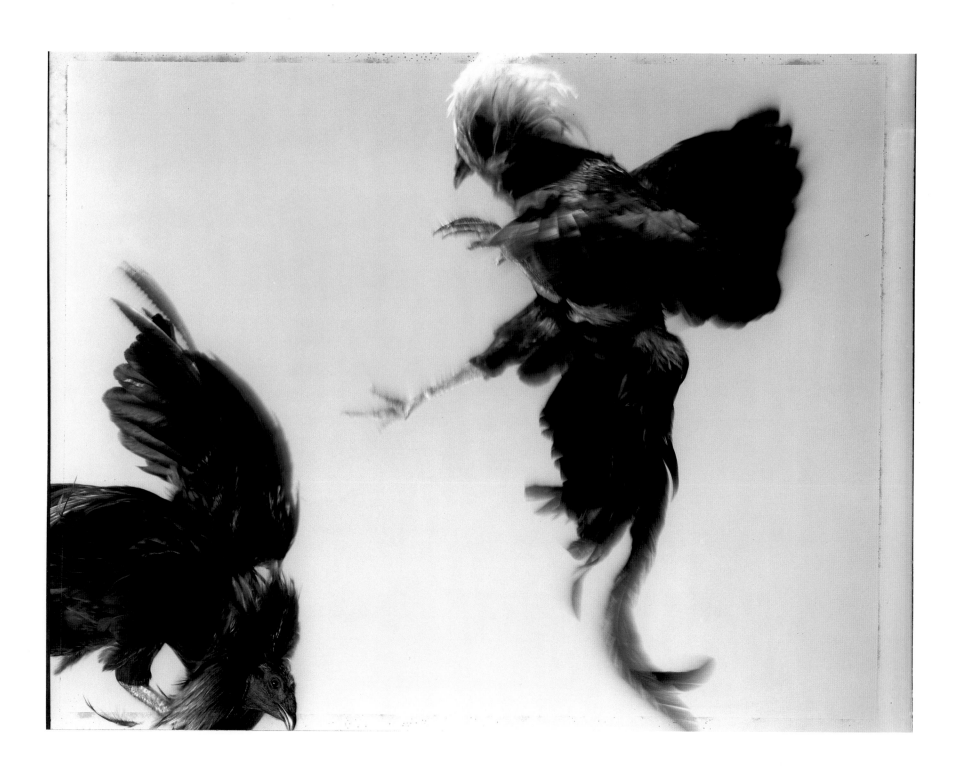

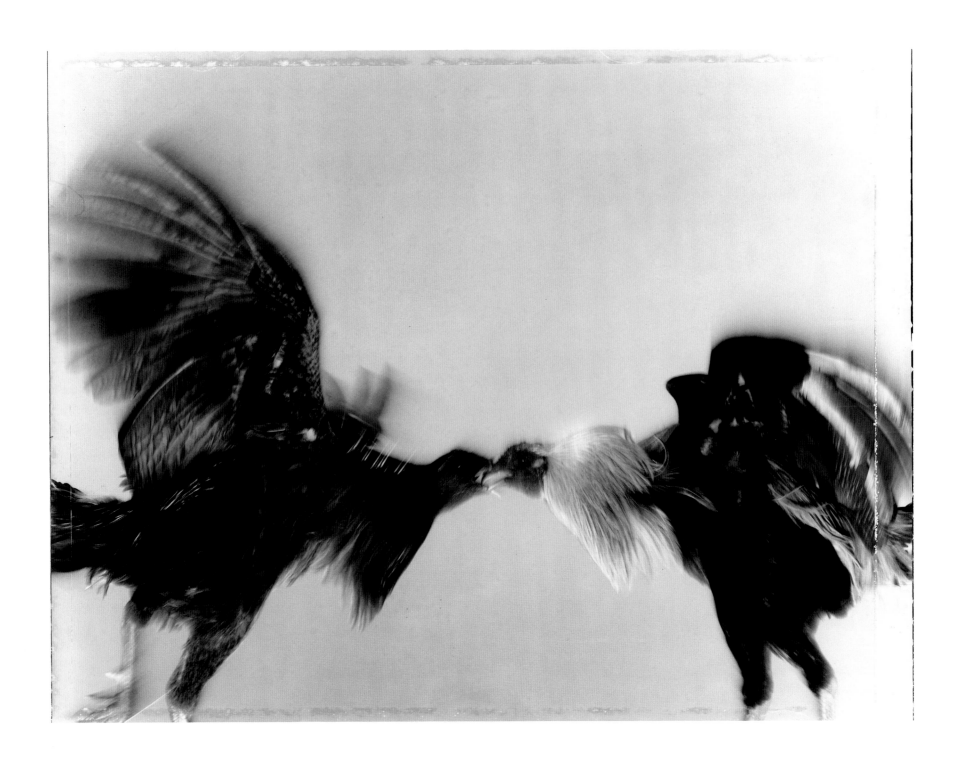

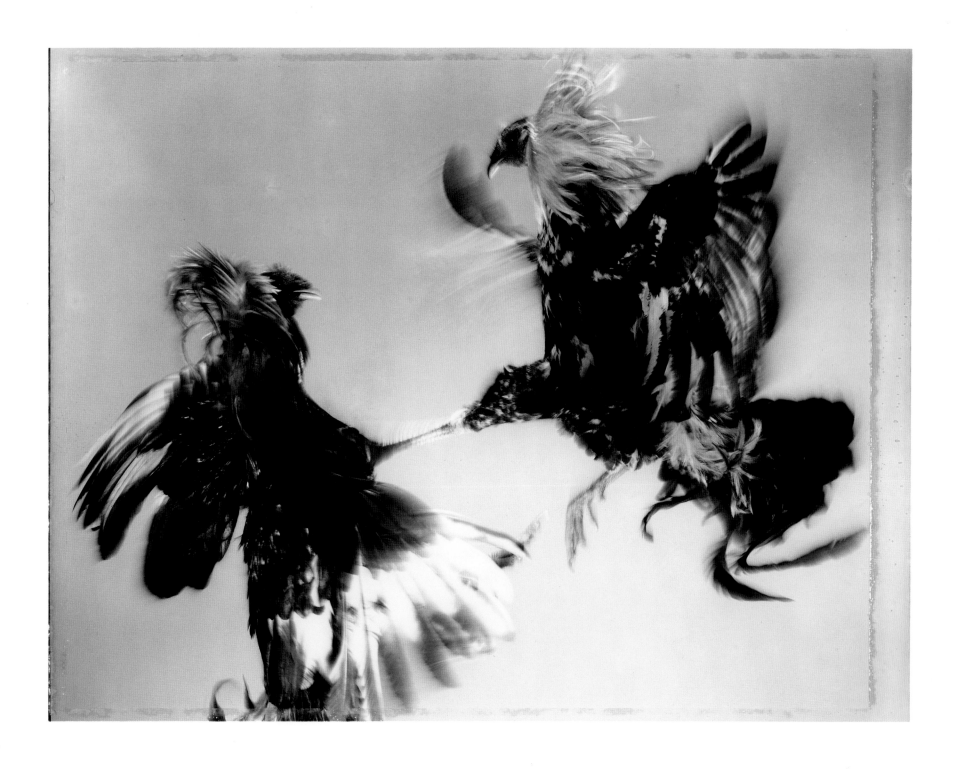

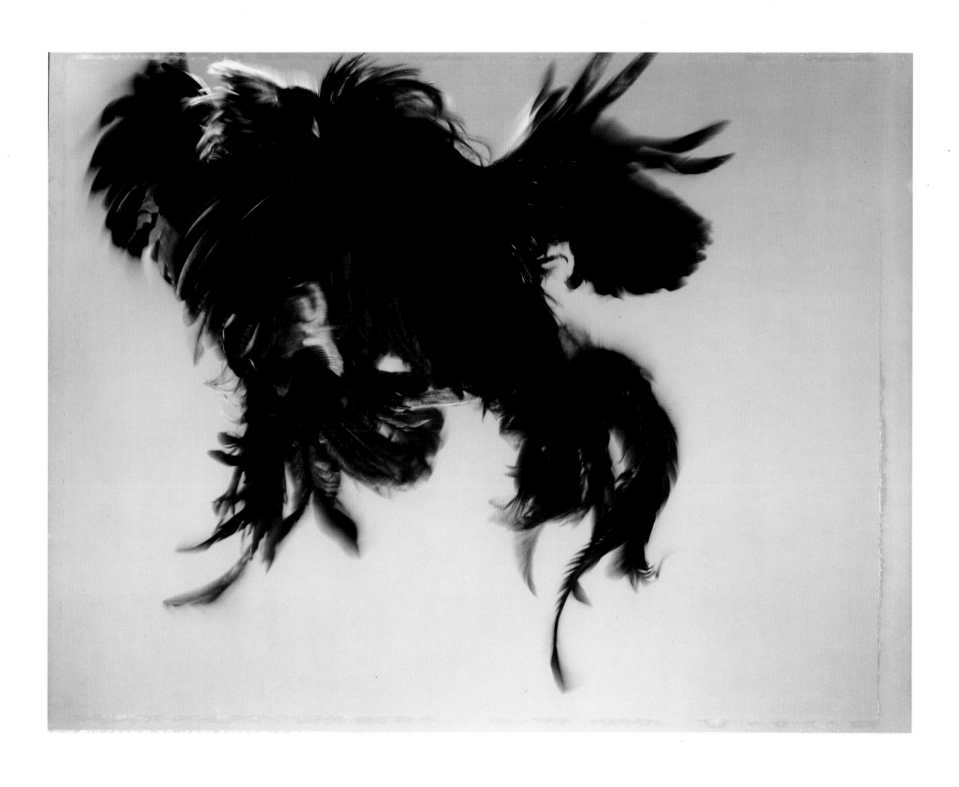

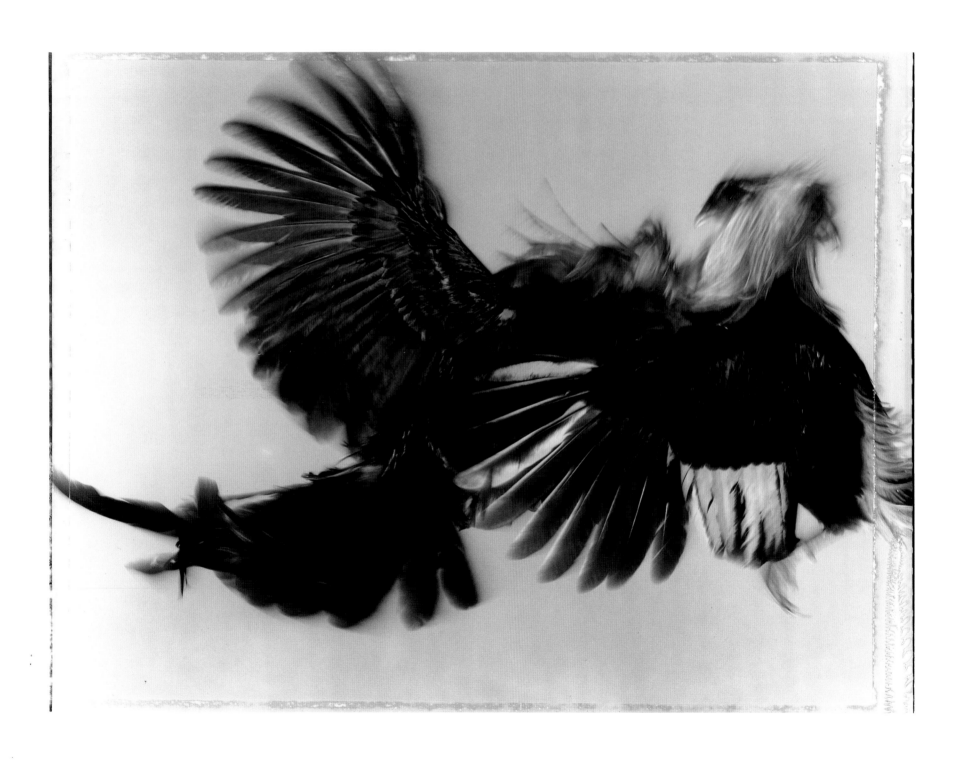

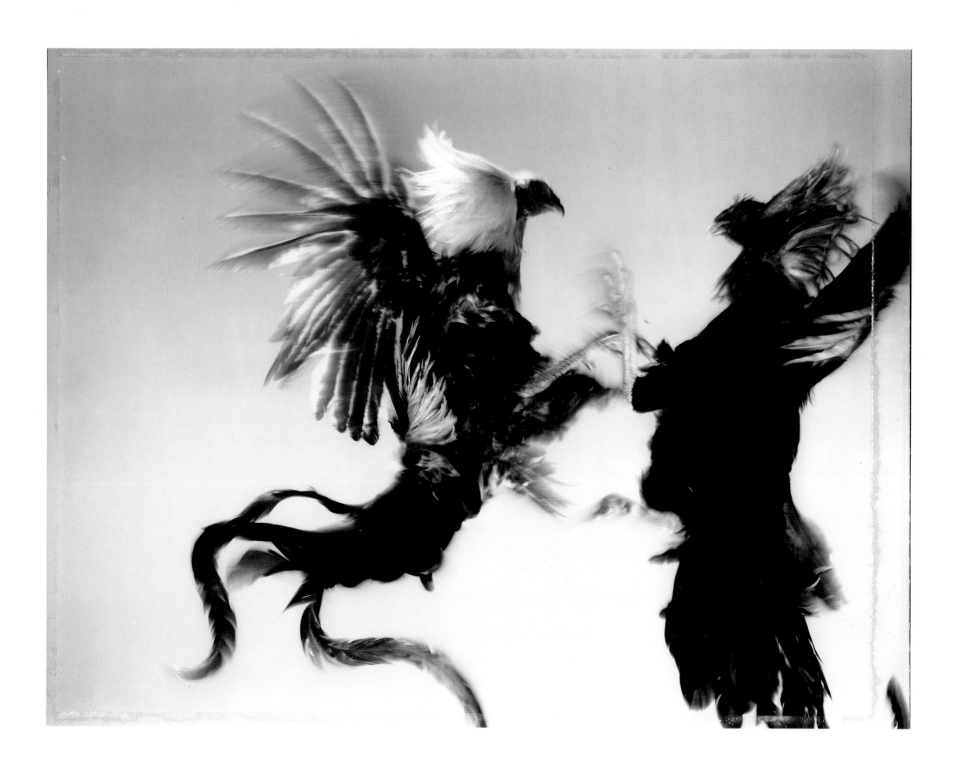

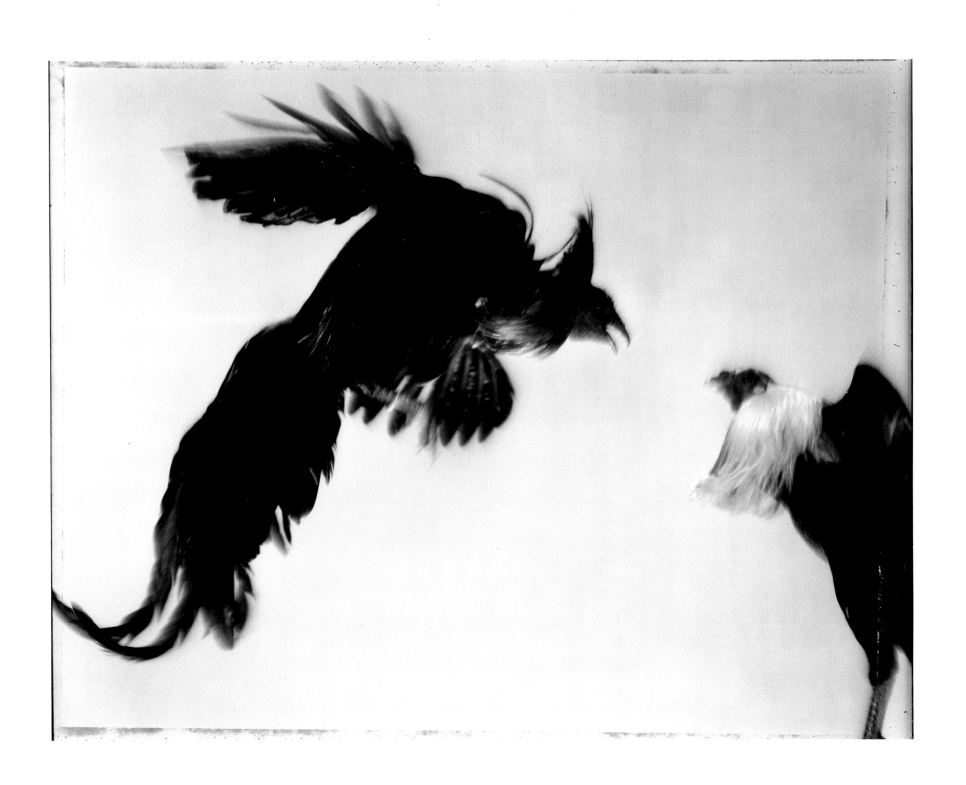

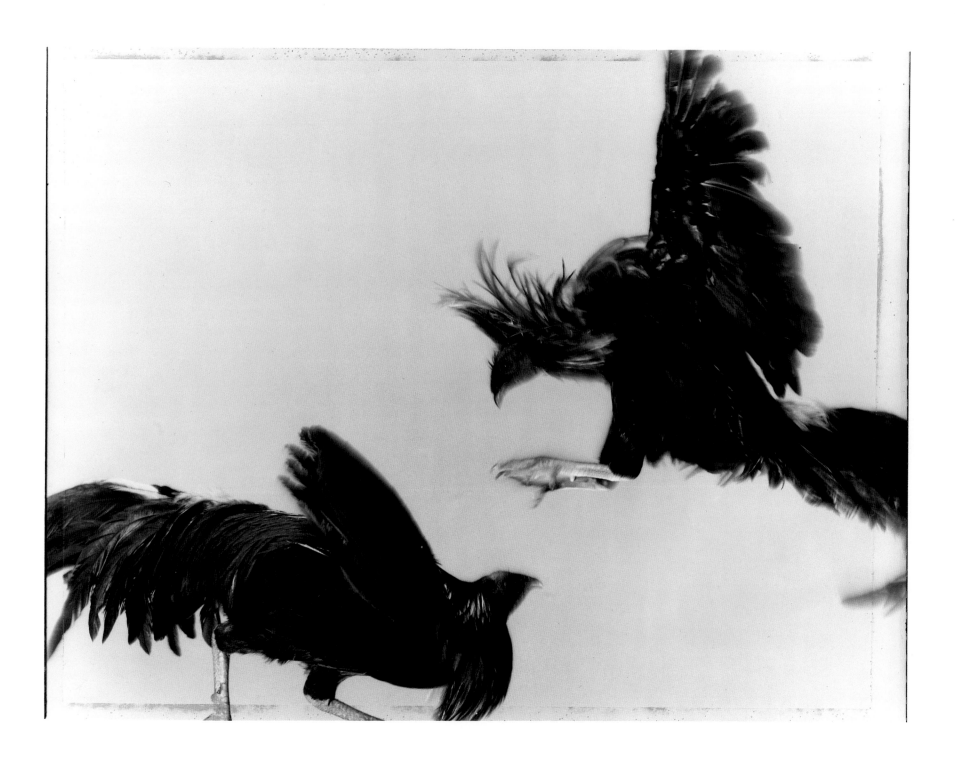

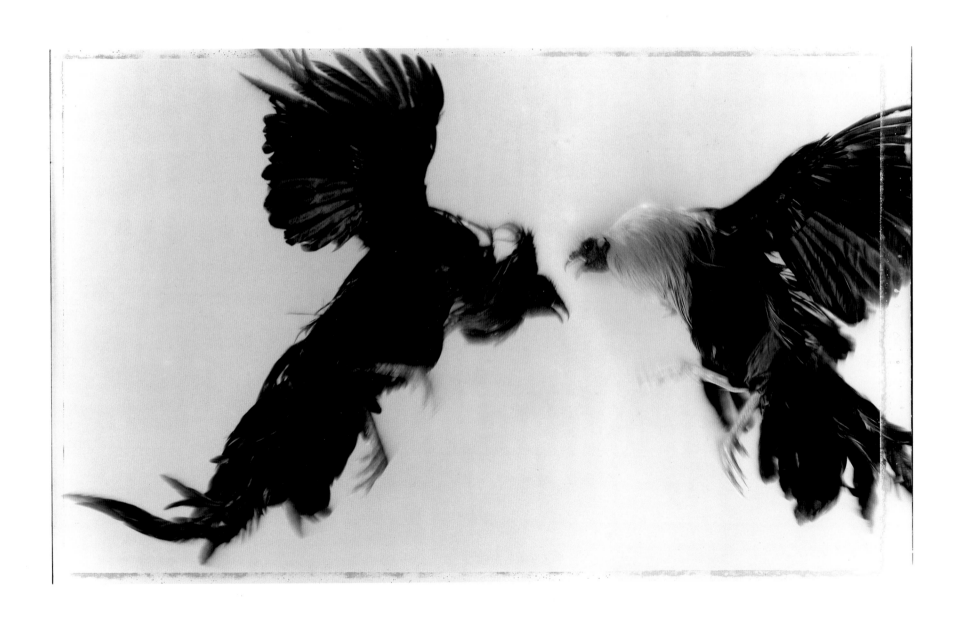

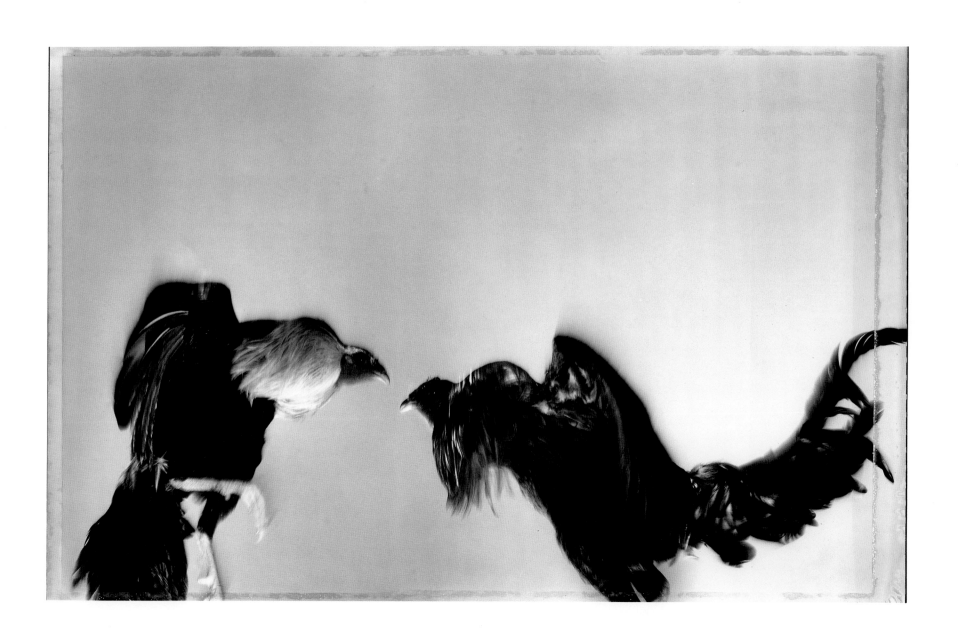

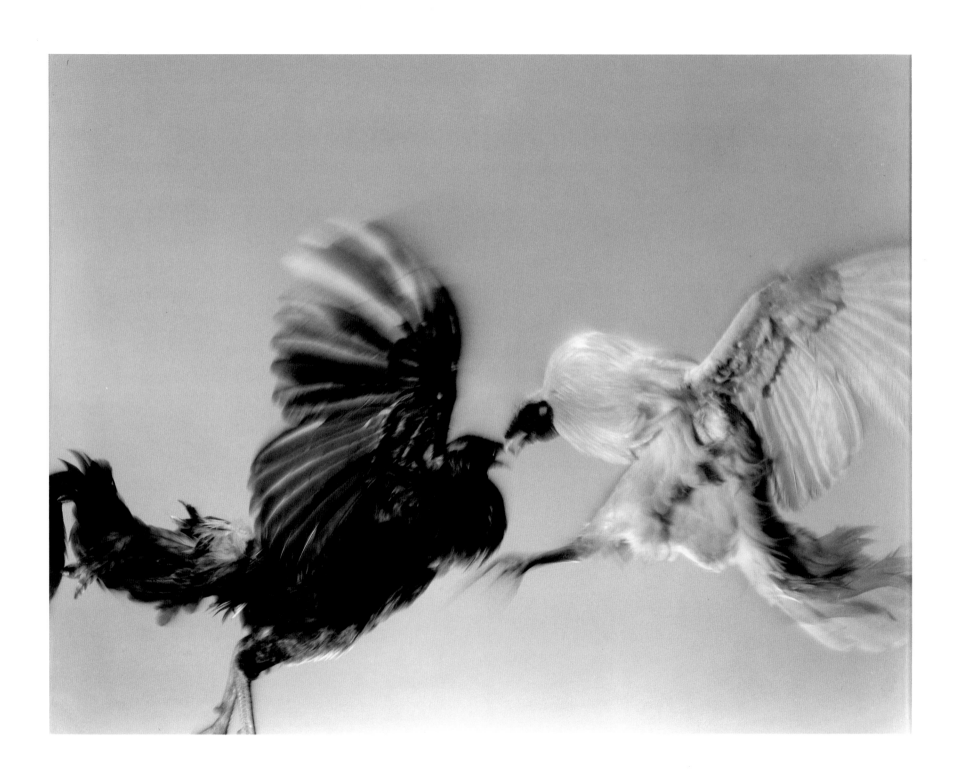

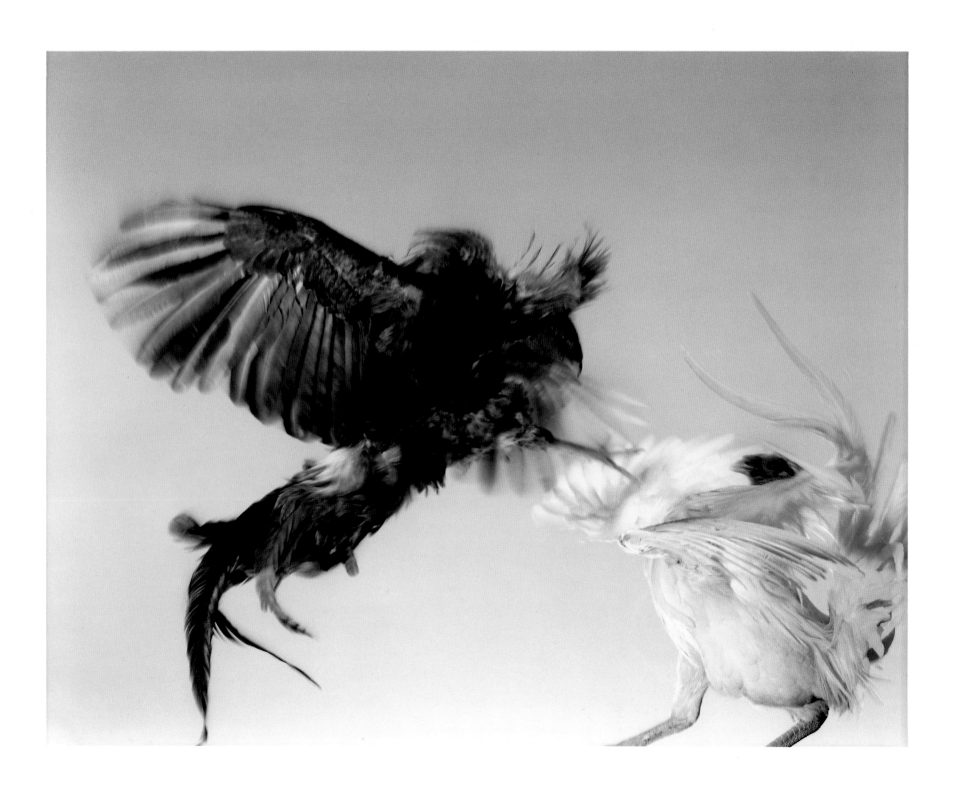

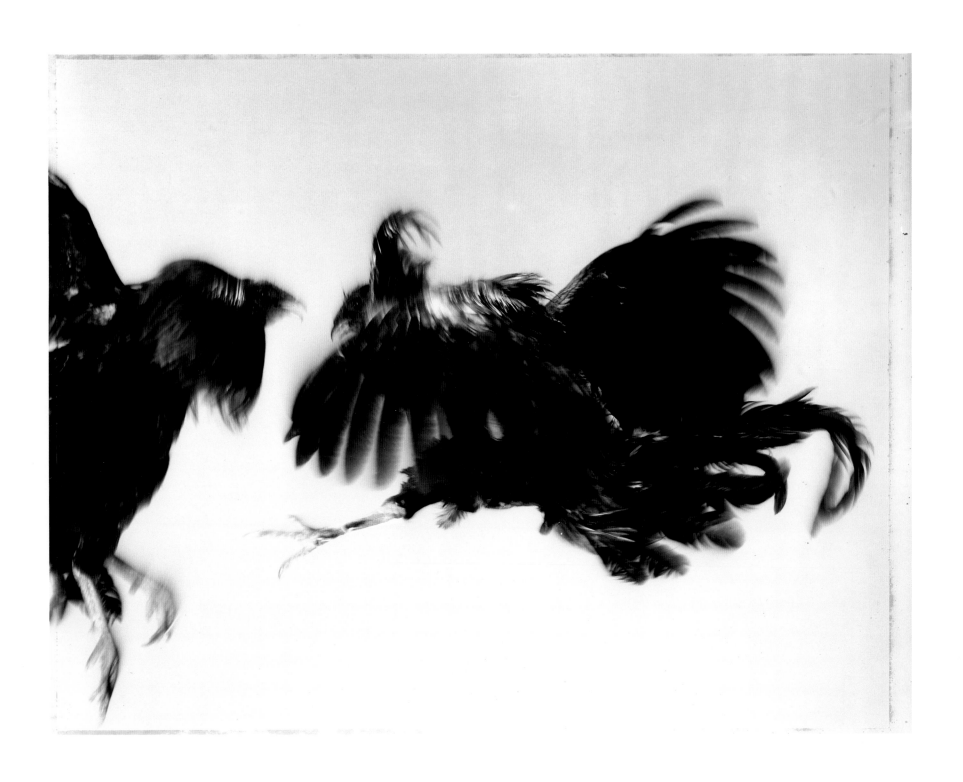

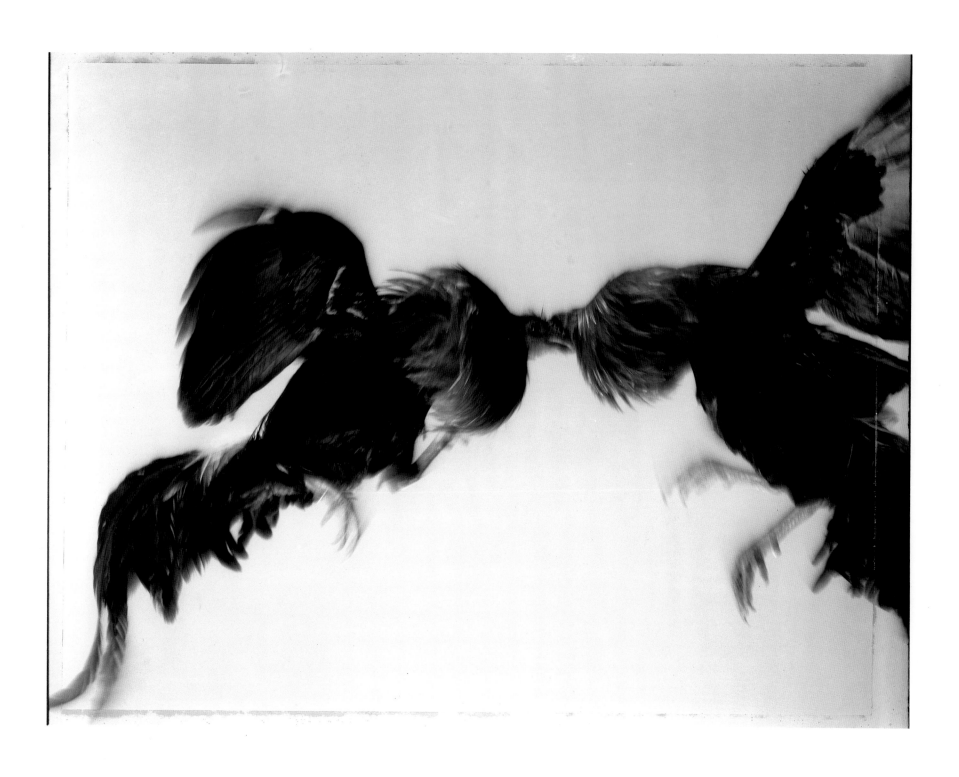

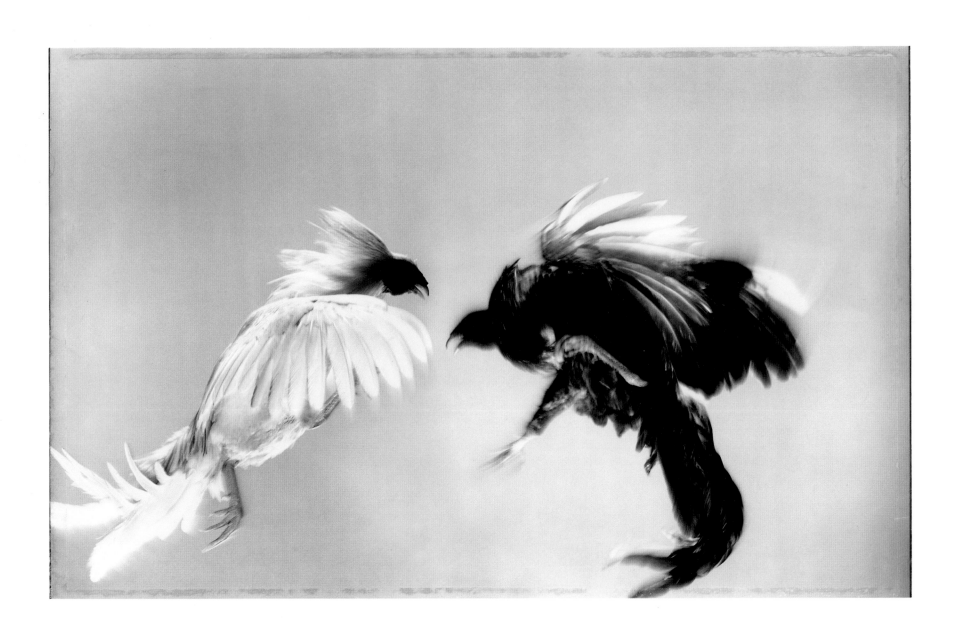

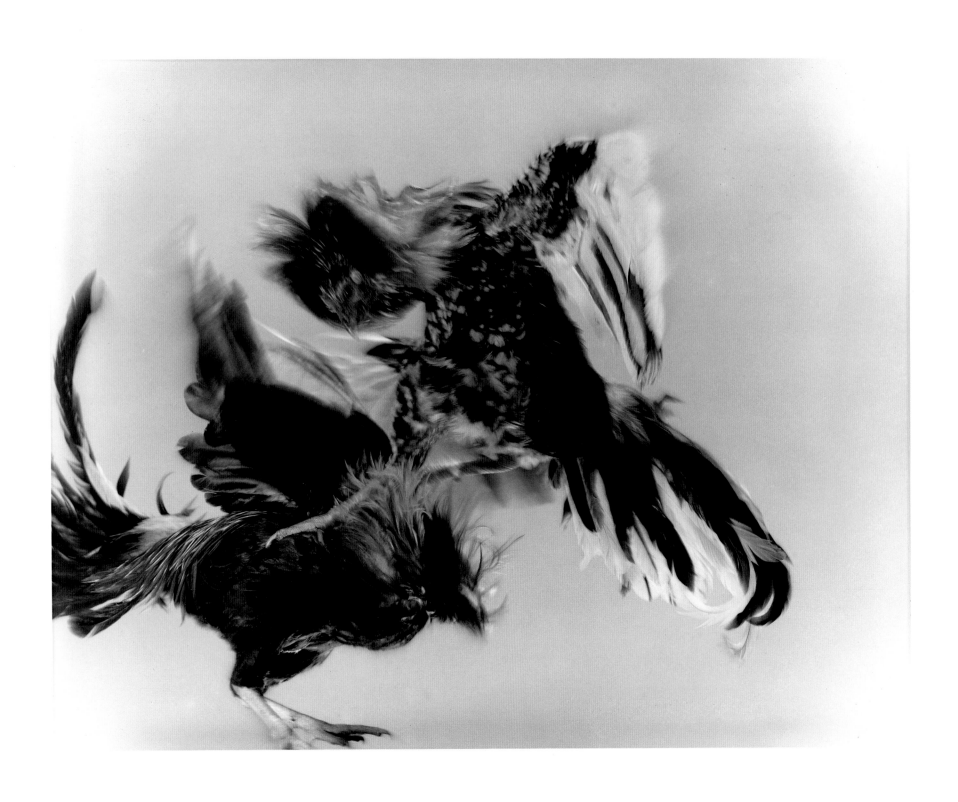

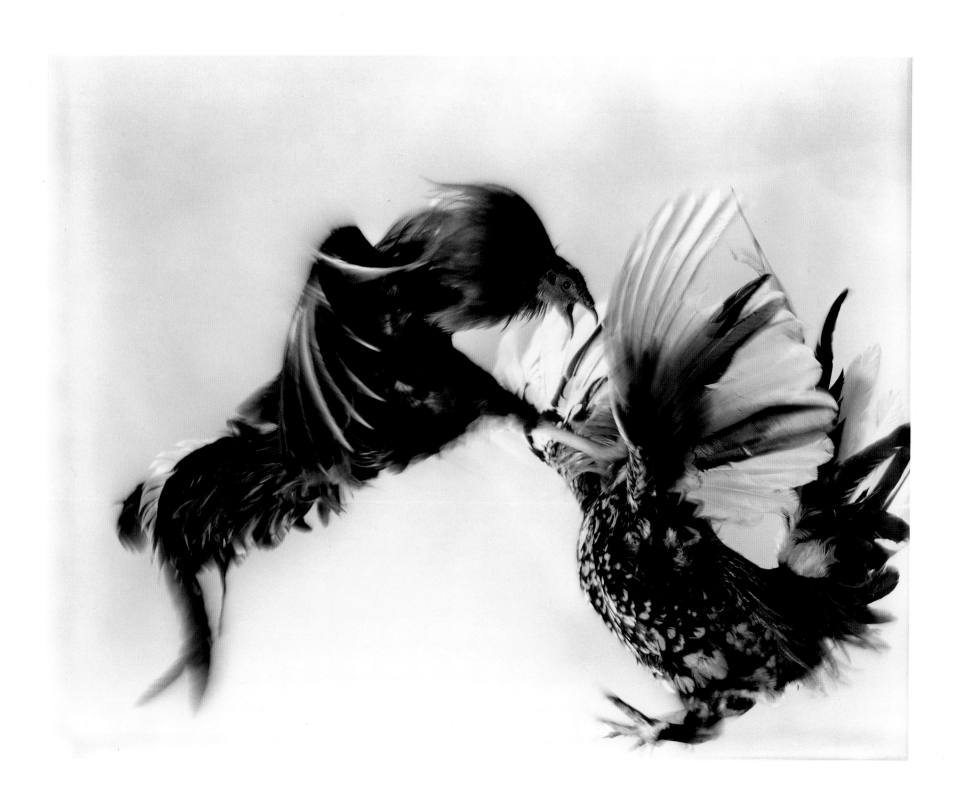

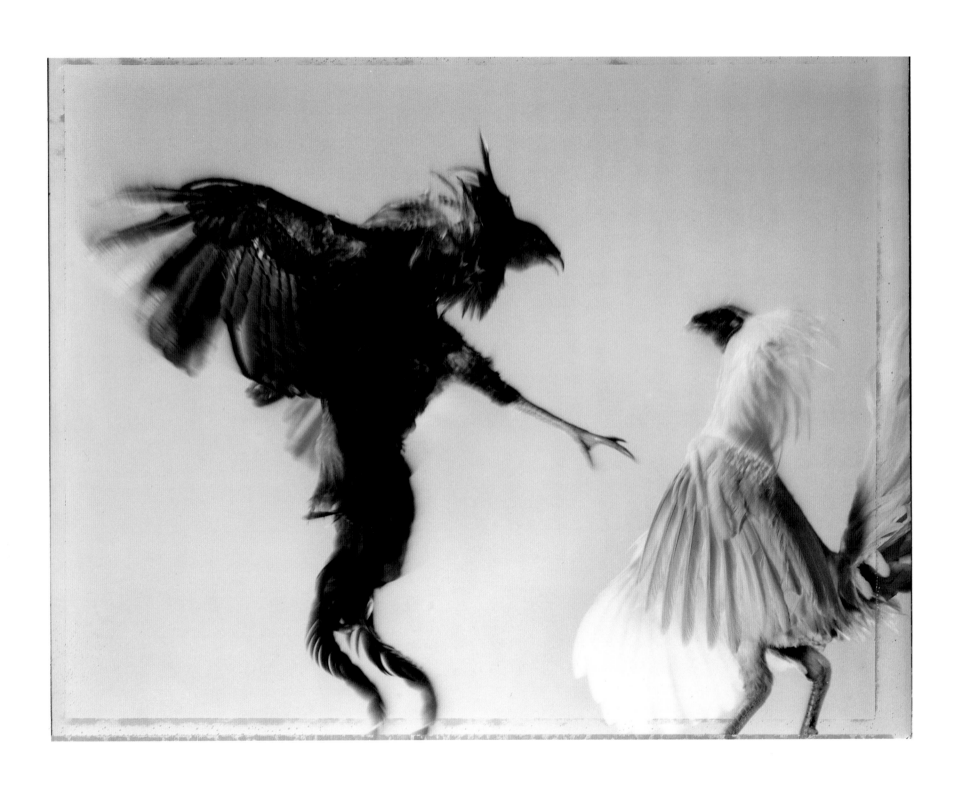

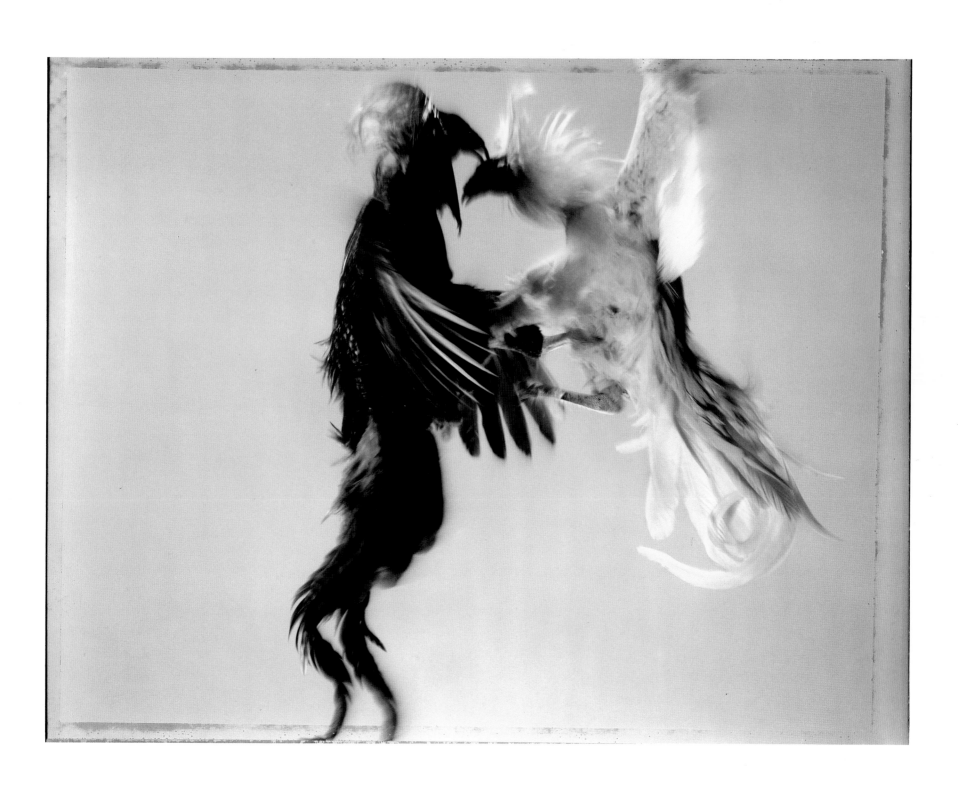

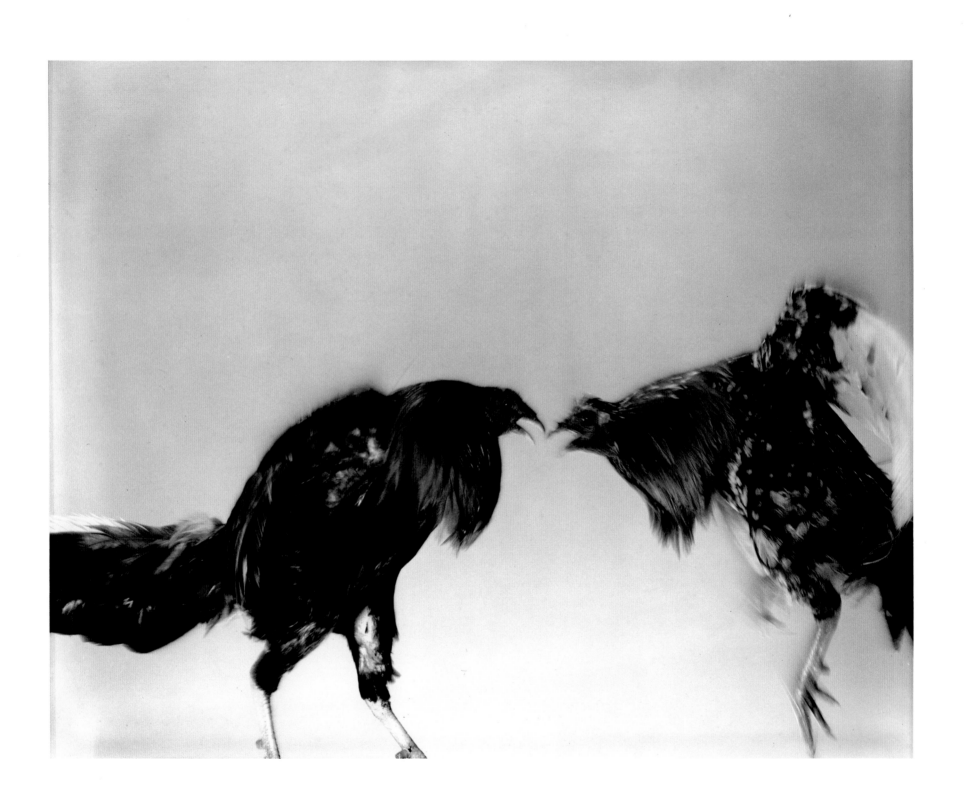

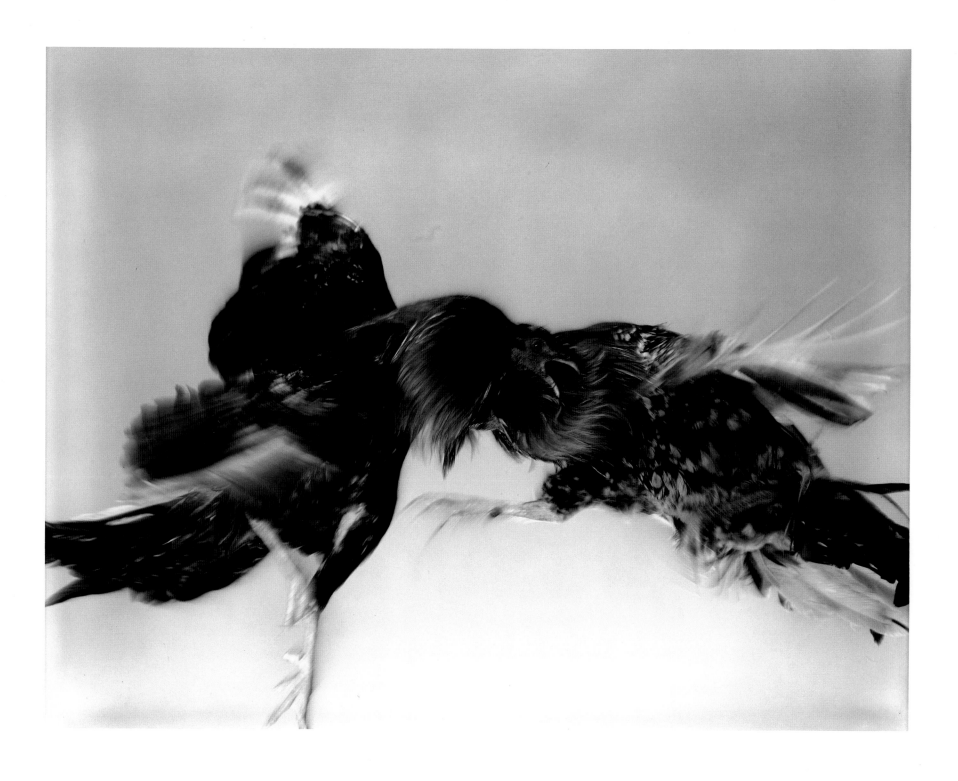

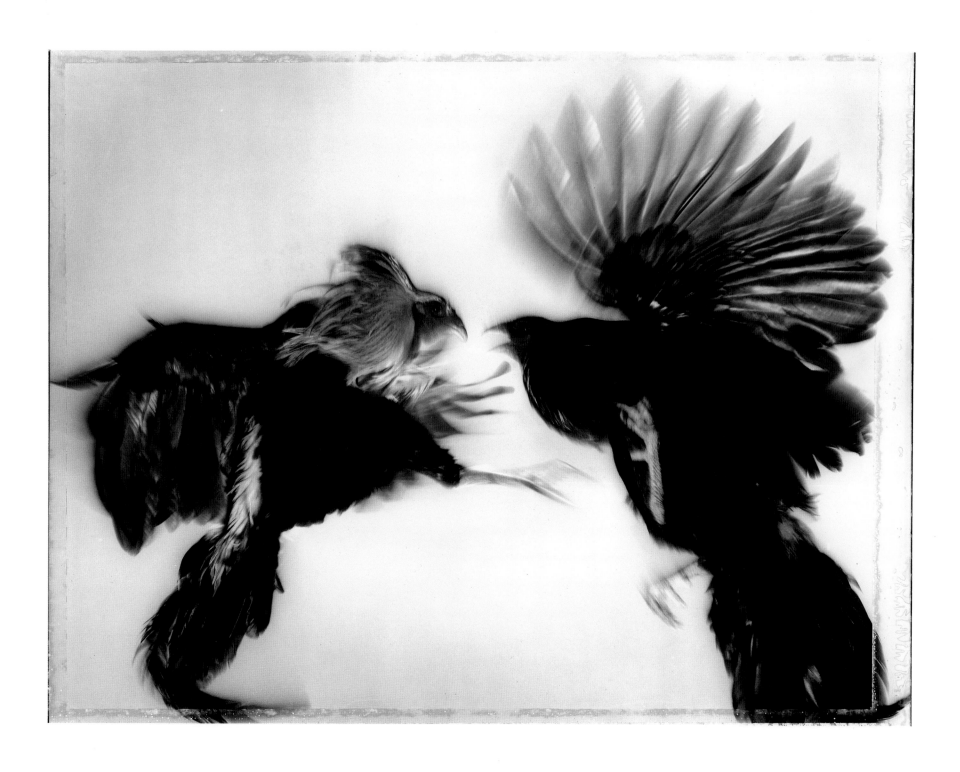

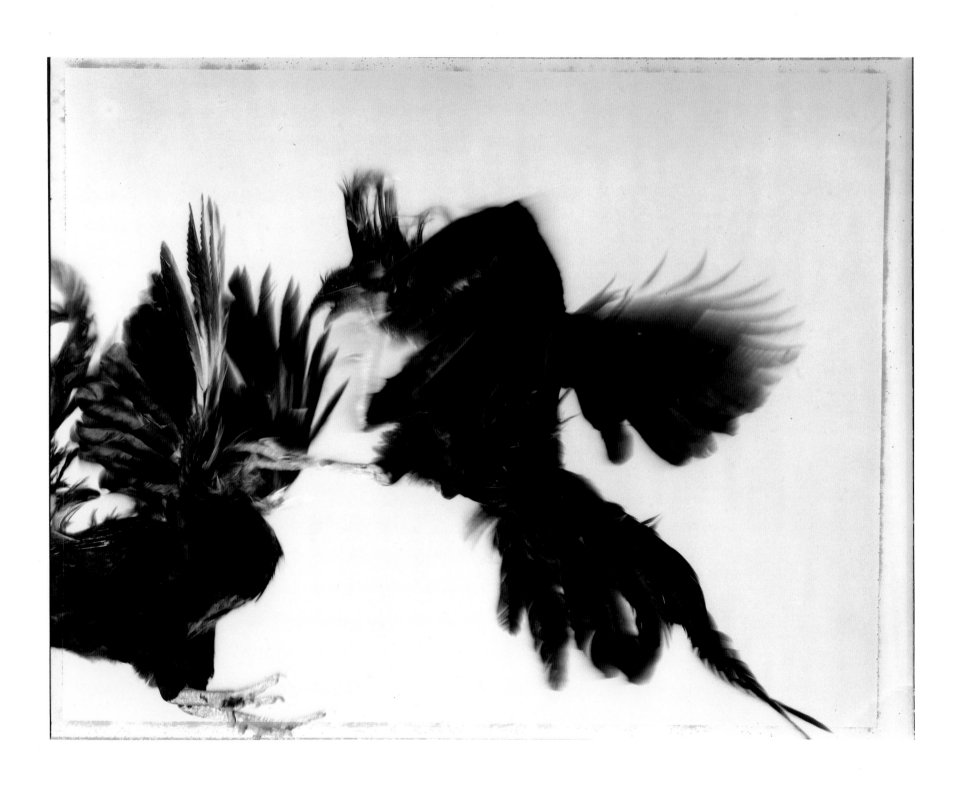

ACKNOWLEDGMENTS:

MARY ALBAR
PAUL CORLETT
CATHERINE COOK
JENNIFER CHAITMAN
DAN CUNNINGHAM
CHRISTOPHER HUNTER
LING KUO LI
ROBERT KATO
CAROLYN JONES
FRANCIS WESTFIELD
PAUL MEYER
PHILIP NEWTON
NORMA STEVENS
MITSUYA OKUMURA

THE PHOTOGRAPHIC PRINTS WERE
MADE BY DAVID FRAWLEY

EDITOR: ROBERT MORTON
DESIGNER: ELISSA ICHIYASU

LIBRARY OF CONGRESS CATALOGING-IN-PUBLICATION DATA
HIRO.
FIGHTING FISH, FIGHTING BIRDS/PHOTOGRAPHS BY HIRO;
ESSAY BY SUSANNA MOORE.
P. CM.
ISBN 0—8109—3403—5
1. PHOTOGRAPHY OF FISHES.
2. PHOTOGRAPHY OF BIRDS.
3. SIAMESE FIGHTING FISH—PICTORIAL WORKS.
4. GAME FOWL—PICTORIAL WORKS.
5. HIRO.
I. MOORE, SUSANNA.
II. TITLE.
TR729.F5H57 1990 90—30721
779'.32—DC20 CIP